*Welcome
the
Caribou Man*

Tsonakwa
and
Yolaikia

Credits

Photographer: The photography of Dan Nash has given the artwork another beautiful dimension. His donated services, which made this catalog possible, are sincerely appreciated.

Editor: Ken Hedges

Publisher: San Diego Museum of Man
1350 El Prado, Balboa Park
San Diego, CA 92101

Acknowledgements

Gerard Tsonakwa Tsemitzewa,
 father of Tsonakwa
Edna Sciolé, mother of Yolaikia

The people of Aben at St. Methode,
Obomsawin, Missisquoi, St. Francis
Odanak, and Rivier du Loup

American Indian Archaeological
 Institute, Washington, CT
Arts and Learning Services,
 Minneapolis, MN
Bell Museum of Natural History,
 Minneapolis, MN
Brigitte Schulger, Denver CO
Elaine Horwitch Galleries, AZ-NM
Evelyn Harris Assoc., New York, NY
Faith Nightingale, San Diego, CA
Field Museum of Natural History,
 Chicago, IL
Galleria, Norman, OK
Hayden Planetarium, New York, NY
Idaho Museum of Natural History,
 Pocatello, ID
Illumina, Atlanta, GA
Images of the North,
 San Francisco, CA
Indigena, Stratford, Ontario, Canada
Luther College, Decorah, IA
Many Goats, Tuscon, AZ
Medicine Hat Museum and Art Gallery,
 Medicine Hat, Alberta, Canada
Middlebury College, Middlebury, VT
Museum of the Rockies, Bozeman, MT

Muskegon Museum of Art,
 Muskegon, MI
Objects of Bright Pride, New York, NY
Origins, Minneapolis, MN
Palo Alto Cultural Center, Palo Alto, CA
Pensacola Museum of Art,
 Pensacola, FL
Poindexter Enterprises, New York, NY
Quintana Gallery, Portland, OR
Raven Gallery, Minneapolis, MN
Rogue Gallery, Medford, OR
San Diego Museum of Man,
 San Diego, CA
Schweinfurth Art Center, Auburn, NY
Second Street Gallery,
 Philadelphia, PA
Sedona Art Center, Sedona, AZ
Snow Goose Gallery, Seattle, WA
Staten Island Institute of Arts
 and Sciences, Staten Island, NY
Tacoma Art Museum, Tacoma, WA
The Smiths of Coonley Playhouse,
 Riverside, IL
Thorne-Sagendorph Gallery, Keen, NH
Thunder Bay Exhibition Center,
 Thunder Bay, Ontario, Canada
University of Arizona, Tucson, AZ
University of Maine, Orono, ME
University of Minnesota, St. Paul, MN
Vermont State Historical Society, , VT
Wheelwright Museum, Santa Fe, NM
Woodlands Indian Cultural Center,
 Branford, Ontario, Canada
Ya-Ta-Hey, New London, CT

Table of Contents

Preface

"The Great Spirit is in all things." That is what an Abenaki Indian told ethnographer Natalie Curtis ca. 1907.[1] Today, after nearly a century of cultural disruption, that concept is finding renewed expression in the works of Abenaki artists Gerard Rancourt Tsonakwa and his wife Yolaikia Wapitaska. Working with bone, stone, and wood, they are helping the peoples of the post-industrial age to perceive the spirit inherent in natural materials. In doing so, they are not only reviving an ancient artistic legacy, but also transforming it through the use of new tools and materials made available by modern technology. They are able to utilize the innovations of industrialized society while maintaining the spiritual and cultural integrity of a hunter-gatherer way of life. Reverence and respect for natural materials illuminate their approach and are a constant in their work.

This blending of the old and the new is one of the hallmarks of contemporary native arts around the world. A century ago, anthropologists viewed traditional cultures as being in the final stages of extinction. Today, in the last decade of the twentieth century, what anthropologist Nelson Graburn refers to as the "fourth world"[2] is experiencing a remarkable florescence. Much of this resurgence comes from the information revolution brought about by modern communications and transportation. On one level these influences foster mass production and commercialism. Yet, at the same time, a great deal of fine art is being produced. With the development of such art, native cultures are being rediscovered and regenerated. As these traditions are brought into the aesthetic mainstream, all of us benefit.

Tsonakwa and Yolaikia are contributing to this universal enrichment. Their works are illustrations of what surrealist artist Salvador Dali called "the crisis of the object." According to Joseph Campbell, Dali's concept involved "a displacement from an outward to an inner space" similar to that experienced by the artists and shamans of traditional hunting and gathering societies. In this process mythic thinking and imagery are the vehicles of "a crisis of introjection...initiating and enabling a spiritual transformation."[3]

The work of Tsonakwa and Yolaikia expresses the concept that there is more to be perceived than is seen by the organs of sight; that there is a level of seeing that invokes ancient connections embodied in the legends and lore of traditional peoples. These connections are timeless; they are as compelling today as they were when the stories were born. Animal imagery, reinforced by the oral tradition of the forefathers, is the primal medium used to convey these relationships. The works in this catalog illustrate a metaphorical fusion of sight and sound, the blending of story and image, which has the power to bring forth the inner life of the viewer and the viewed. We are reminded of the web of life which links man and animal to each other and to the "ultimate ground," the central core of all being.

—Douglas Sharon, Director
San Diego Museum of Man

REFERENCES CITED

[1] Natalie Curtis, *The Indians' Book: An Offering by the American Indians of Indian Lore, Musical and Narrative, to Form a Record of the Songs and Legends of Their Race* (New York: Harper & Brothers, 1907), p. 11.

[2] Nelson H. H. Graburn, ed., *Ethnic and Tourist Arts: Cultural Expressions from the Fourth World* (Berkeley: University of California Press, 1976), pp. 1-2.

[3] Joseph Campbell, *The Way of the Animal Powers, Volume 1, Historical Atlas of World Mythology* (San Francisco: Harper & Rowe, 1983), pp. 167, 171.

Tsonakwa and Yolaikia

Gerard Rancourt Tsonakwa and Yolaikia Wapitaska, husband and wife, are from the Quebec/ Northeastern United States area. Using stone, antler, bone, and wood, they create powerful masks and sculptures which draw from Indian social and spiritual traditions. With modern as well as ancient techniques, they carve works of art which have beauty, originality, and great energy.

Tsonakwa works with stone, wood, and other natural materials. He is also a master storyteller. For many years he has told the ancient legends of the Abenaki and other tribes to fascinated audiences across North America and Europe. Many of these stories are incorporated into the exhibition.

Yolaikia Wapitaska sculpts primarily from deer antler, in keeping with the traditional Abenaki connection between the deer and the female aspect of life. Her small, intricate renderings reveal a cosmology of subtle and mysterious transformations.

Introduction

Caribou Man was a lifelong friend of my father, who first saw him in a dream when he was six or seven years old. My father learned that in the dream world we are intruders. We are apparitions and can be very frightening to the spirits there. My father learned to approach gently and quietly so the Caribou Man would not be scared. They became good friends, and Caribou Man told of things that would happen in the future. Sometimes my father made carvings of Caribou Man's face, and then he would remember things he had been told. In his dreams they might have seemed meaningless, but suddenly the meaning would come clear.

Now that my father has gone on to the spirit world, I'm sure he sees a lot of Caribou Man. Now, I carve Caribou Man's face in hopes that I will see him one day. If I approach him calmly so as not to frighten him away, maybe he will stop to tell me how my father is doing. I want him to know he is welcome in my dreams.

—Tsonakwa,
"Legends in Stone,
Bone, and Wood"

Caribou Caller

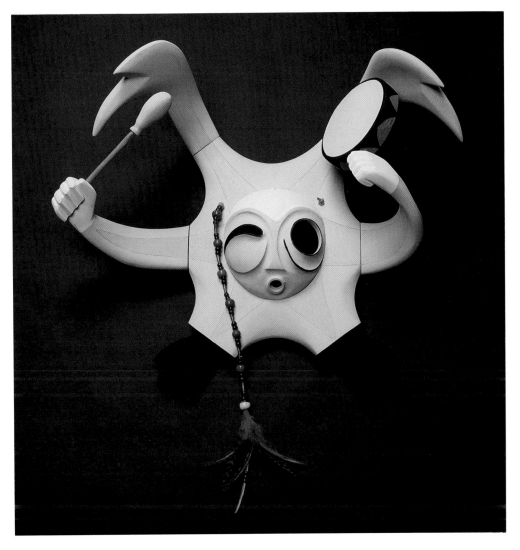

Caribou Caller, Tsonakwa

Caribou Man

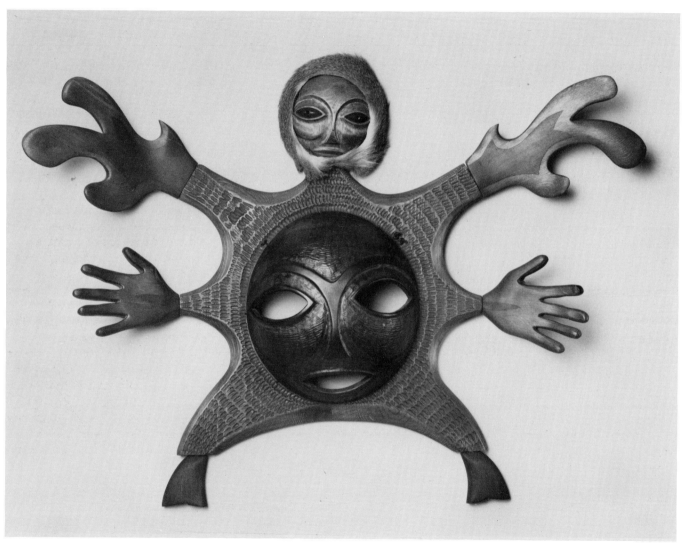

Caribou Man, Tsonakwa

Caribou Man's Monologue

The first time I saw a human, he frightened me. He suddenly appeared in my path without warning and he looked so strange, I ran away. Later, when I became accustomed to him, I learned a lot about his world. The place seems very strange to me but it made perfect sense to him.

The world of men and the world of spirits do not follow the same logic. They are related but different. They are related like day is to night, opposite halves of the same thing. What happens in the world of men and animals has importance to the world of spirits as well as the other way around. If you look into a quiet pool, you see your reflection, somewhat distorted and tenuous—that is how we see each other's world. When you walk in the light of day, you cast a shadow. We in the spirit world are like your shadow except sometimes it is the shadow that moves. Sometimes it is the shadow that casts the man.

Although we dwell in darkness, so few can see us, we are all about. We are not to be seen by your eyes anyway, they aren't the organs of vision. In our nature it is the heart that sees most clearly. We have been "seen" from time to time from the very beginning and that is why, even today, man has persistent subtle knowledge of us. It was in the absolute darkness at the back of the caves that proto-man first discovered us and so finely depicted our countenances and then sealed them safe for tens of thousands of years.

Humankind should have no problem believing in magic, for you live in a universe of changes, a creation world where new things are revealed. A tadpole becomes a frog, an acorn becomes a tree. A worm hides in a cocoon and emerges a butterfly, the snake sheds its skin. The Creator is like a magician, everything is coming and going from his magic box. He keeps a few things and changes some others and all life must adjust. Human people begin life as four-legged, crawling on the ground. They become two-legged, running swiftly over the highest mountains. At last, they become three-legged, with two shuffling feet and a walking stick. Nothing stays, nothing lasts, only the mountains and the sky.

The world of spirit has no changes. Our spirit culture is very old indeed, as old as creation. Against the world of change, we are stability. In an uncertain universe, we are certain. We give that sense of security where mankind has sheltered himself in faith to accept events out of control. We have been the spiritual strength through which man has altered great events to his benefit.

The great secret in the world of men is that the world of spirits exists. The great secret in the world of spirits is that there is no secret.

The Treasure Box

How can we believe a world of spirit that we cannot see? How can we accept a world of spirit dwelling simultaneously with our world? Maybe this vignette can help us see things we cannot see, understand things we cannot prove or hold in our hands.

Imagine that you are a child at home and in that safe place you may have many wonderful things that you love. Now imagine that you must leave your home and you don't know how long you will be gone. You want to take your special things with you but you cannot—there are too many and they are too delicate. You must leave these things behind, so you put them in a box and hide them in a safe place and then you go away, hoping to return.

As long as you are gone you think of these childhood treasures you have hidden away—you love them and hope they are safe. You are gone a long time and you think of these precious things. Now if something happens, even if someone takes these things of yours and you don't know, they will still exist for you in your heart and mind. No matter that those things are gone, you still see them and they are waiting for you. If you never return, those things will safely be kept in the very core of your being forever.

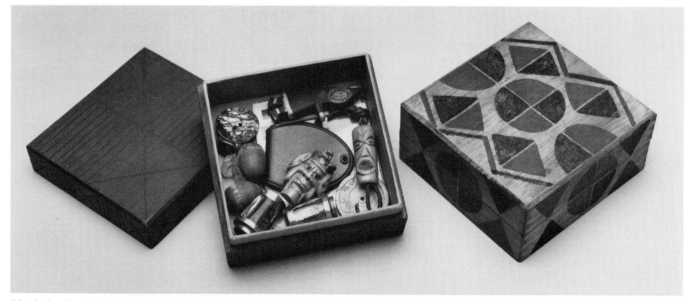

My father kept and decorated many boxes. My mother gave these to me after my father passed to the spiritual world. They hold important symbolic things. Each item is a mnemonic, a coded reminder like the picture-symbols of our wapapi records. When read like heiroglyphs, these things illustrate the entire span of my father's life.

Bear Box

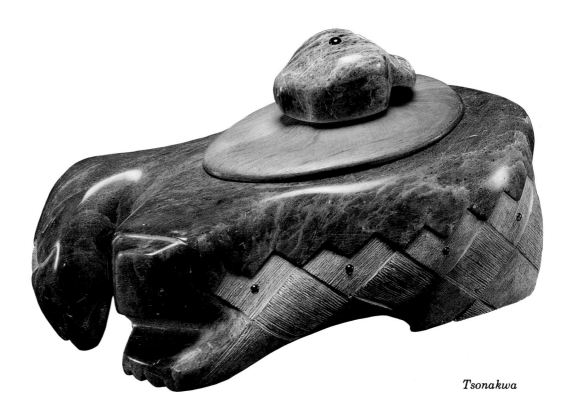

Tsonakwa

This box is Ours Rampant—Angry Bear. His mighty paw is raised as a warning to intruders. This box is small, for it is not meant to hold much material wealth—it is for some personal memento, a great spiritual treasure. The box itself may seem to have more material value than what it holds and protects. Our physical life and body have immense value, but even that is nothing to the soul it contains.

At various times in our lives, we should make small boxes and fill them with things. Some treasure of memory, an item of the heart.

11

The Dreamer

In my dream, I awakened. I turned to my side and saw the morning sun shining through a dew-covered spider web. So beautiful it was! It was filled with sparkling color, a million tiny lights in a hand's breadth. A black and yellow spider was busy repairing a tear in the web from an insect that got away. The spider stopped and stared at me. It spoke to me in a tiny little voice and said, "This is a Dream Net, it only lets good dreams through. This hole was left by the dream you are dreaming now!"

—My father's dream
in the shadow of Odziozo,
Summer, 1949

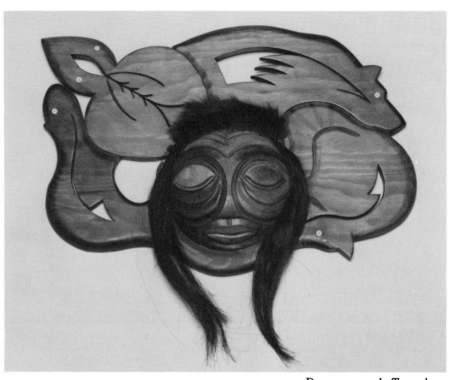

Dreamer mask, Tsonakwa

Maheo, the Great Manito, became tired of the endless silence at the beginning. The Great Manito, Creator, was tired of the terrible darkness at the beginning of time. He wished to fill endless space with light and the joyful movement of life. Out of His great hands flew the sparks of the creation fire, filling endless space with light. He bid Mikchich, the Great Turtle, to emerge from the water and become land. With His strong hands He molded a creation world with mountains and valleys. He put the waters all where they should be and set white clouds sailing in the blue sky. Then, the Manito looked at all this and laughed. He looked at this and said to Himself, "This is good. This is the creation world I want. Everything is ready now. I will fill this place with the happy movement of life."

Maheo, the Great Manito, thought about what kind of life He would make. He carefully considered how He would make a perfect web of life with each

creature just so and in perfect place. Each should have a perfect way of life and all would be happy in this creation world. Long into that last night before creation began, the Manito thought out a perfect plan. He was sure at last there was no flaw, no imperfection. Long into that night He thought until He became exhausted and went to sleep. Soundly did He sleep, and His sleep was filled with dreams. Strange dreams He had.

The Great Manito dreamed of a strange creation world, filled with strange beings, not at all what He had planned. They walked on four legs, some on two. Some creatures crawled, some flew with wings. Some of these swam with fins. There were plants spreading out, covering the ground everywhere. Insects buzzed, geese honked, and moose bellowed. Men sang and called to each other in this strange dream. This was a world with no design at all, no order. This was a bad dream indeed, no world of creation could be this imperfect, this mad!

And then the Great Manito awakened to see a porcupine nibbling on a twig and to His dismay He realized the world of His dream had become Creation indeed!

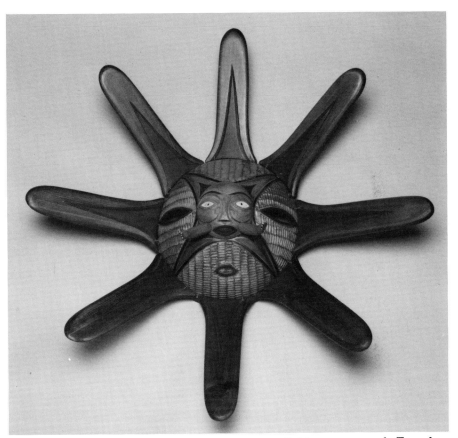

Spiderwoman mask, Tsonakwa

Abenaki Trinity

And so it was in the beginning and the world was a beautiful place. My people walked about the world and saw this great beauty, but there was nothing for them to eat, for they would take nothing from the creation. It was so beautiful, indeed, and they did not eat. And my people, who were great and strong, became small and weak. Our Pudjinks-skwes saw that my people were becoming small and weak and she took great compassion in her heart, pity indeed, to see this.

And she knelt down upon the earth and she dug a hole. She dug deep into the earth and then she began to pull something out. She grabbed something that had antlers and she pulled it out by the antlers and it came out upon the earth and it ran about. And then she reached in and she pulled out more of these by the antlers and they danced upon the earth. And she pulled out so many of these that my people didn't know what to call them, so we called them mosquitos. So many deer there were in those early days of creation time and my people called them mosquitos. They were everywhere and they filled the world and Pudjinks-skwes told my people, "Go now. Eat these. Take

their life in a sacred manner. Take only their physical being, not their spirit, too. Give them great respect and do it prayerfully." And so my people did.

They ate the big deer and they became big. And they ate the strong deer and my people became strong. They ate the swift deer and my people ran swiftly across the mountains and through the broken forests. And they took the deer

that barked in the winter and my people's voices were beautiful. For when they had finished eating all of the big deer, and the strong deer, and the swift deer, and all the deer that bark in the winter, all these deer were gone. And there were sick deer, and lame deer, and my people had to eat those. And my people became sick and lame. They were no longer big and strong.

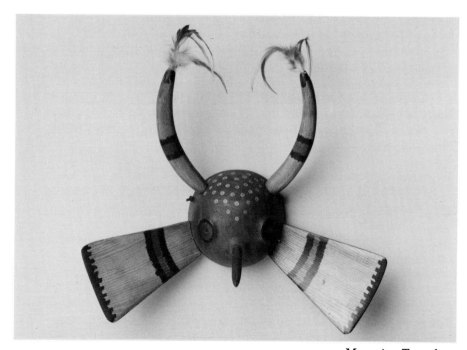

Mosquito, Tsonakwa

14

And Pudjinks-skwes saw this, our old witch, and she took great compassion in her heart, pity indeed, to see these things. And so she knelt down upon the ground and she dug a hole right next to the first hole. She reached into that hole and she pulled out something by the ears. And it was wolf. She pulled out many of these and they ran among the deer. The wolves took the lame deer. And the wolves took the deer that were old and sick. And they took them into their life, but the wolf was so strong that nothing could make the wolf small. Nothing could make the wolf weak. Nothing could make the wolf sick. And all that was left was the strong deer and the big deer that my people should eat. And so, wolf and deer and Abenaki are braided like a rope for creation time.

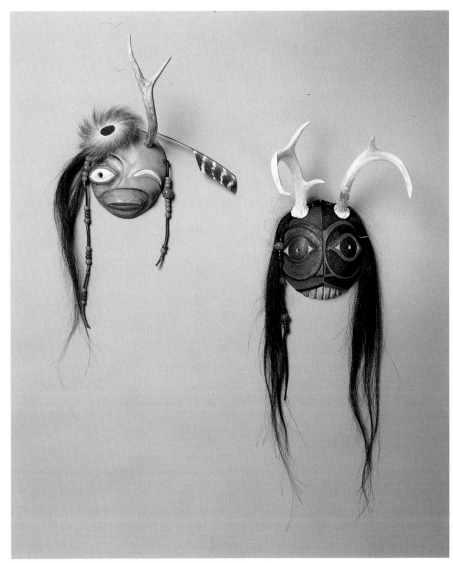

Pudjinks-skwes, left, and the Deer Spirit, Tsonakwa

15

World of Animals, World of Spirits

At the early dawn of creation, at the first instant of the creation of humankind, a pact was made. This condition of existence would haunt humankind for a million years and more, especially in the darkest hours of the night or in the absolute stillness at the back of the cave, for we humans are not only mortal, but we have knowledge of our mortality. It is an agreement we must know, a meeting time and place for every soul. In a proverb of the hunter it says this: "We men, born to die, must live so the world of men and the world of animals can be one world. We men, born to live, must die so the world of men and the world of spirits can become one."

So it is that our mortality is recognized in the endless creation we perceive and in the dreams we dream in those dark hours of night.

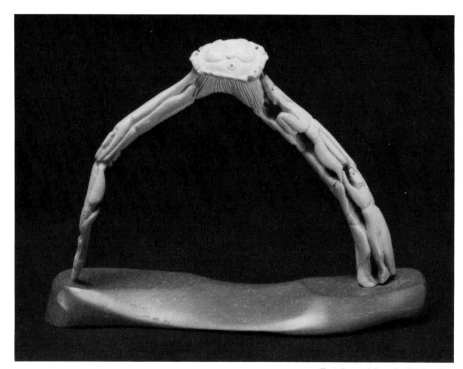

Bridge of Souls, Yolaikia

Contemplation

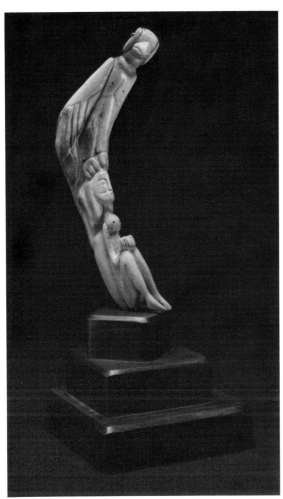

Yolaikia

Aspirations

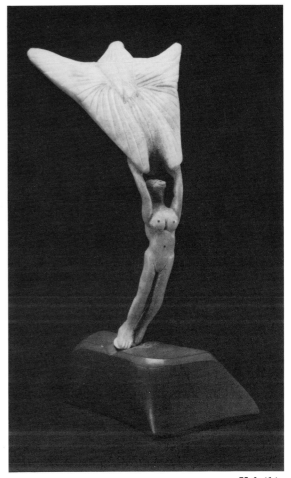

Yolaikia

17

The Great Bear of Aben

The English called us "Terrantines" and said we were savages. The Dutch said we were the most handsome people in the New World. The French called our land a terrible wilderness and the Jesuits said we were the most miserable and godless people on earth. To the Kitimat we were "Head Pounders" and to the Iroquois we were "Bark Eaters." The Mohawks said of us, "They attack like Wolves and disappear like Foxes." We are the "People of the Dawn" and are brothers to the Bear. The Wolf is our legend but we should follow the Bear.

Bears are the most complicated personalities in the forest. They can be very shy or they might come right to your front door, as they please. They bring down a deer one day and on the next they sit and eat blueberries one by one, as their taste suits them. At the maple-house, they can be clowns balancing buckets on their heads, but nothing is as frightening as the charge of an angry bear.

Bears are so powerful that no one in the forest would antagonize them. So it is with true power, it seldom needs to be used; great strength is very gentle.

Our people have been like a great bear sleeping in winter. Our old ways, our images and traditions, have been locked in dim dreams beneath the winter snow. Even in that long deathly sleep the ancient power of that dormant bear survives, slowly now awakening to the warmth of the waxing sun of a new spring.

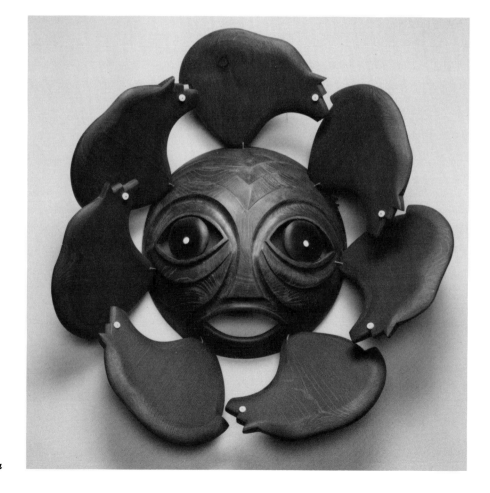

Bear Clan mask, Tsonakwa

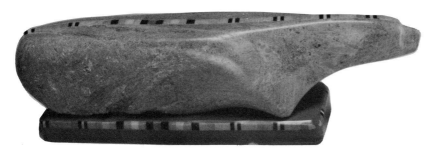

Ours Angulaire, Tsonakwa

Kit'lintowanen aut niweskwuk;
Kwicimkononowuk nohowuk kittonkewin-wuk
Nosokwat muwiniyul
Nit meskweh tepnaskiewis
Meskweh nosokwatit muwiniyul

We sing on the road of the spirits;
Among us are three hunters
Who follow the bear,
There never was a time
When they were not following the bear.

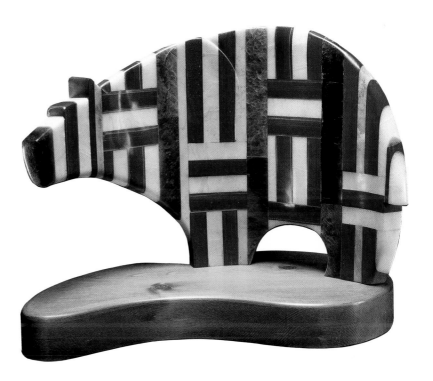

Bear Fetish, Tsonakwa

How Mikchich the Turtle Appears and How the First People Follow the Bear and Find Aben

*Pemkiskak kisadjiti-tit keikyi-titit,
kehtti-match-yutyik.*
*Weh-tiyan: "Metch-te pi-tjeto
kehtak-mikwe yu."*
*Ankwotch, metje nihi sunteh
kesena-te peskweh kisos, wela
nosokwat muwin-iyul.*

When they prepare what they have, they go to travel.
He says to her: "The land is still far off."
Some time, two weeks more or one month, they follow the bear.

When Mikchich comes to the surface of the water, when his shell breaks the surface of the water, it becomes land. Then Mikchich comes out of his shell, he gets out of his shell to look around. Then Mikchich sees that he is on the land, a great island in the water. He sees mountains and trees like in the forest. There is a world with everything on it. Mikchich says to himself: "This is a big surprise!"

Then two appear. When they appear, they are First Man and First Woman. They ask, "Where are we now?" Mikchich says, "You are standing on my back; you are standing on Great Turtle Island." Then these three go to travel.

They walk until they are tired. So big is Turtle Island, they walk many times until they grow tired. They don't know what to do, they have no place to go. They are starving.

Then one comes along. This one is Muwin-iyul the bear. He is a black bear, he leaves black footprints. He says to them: "Follow me to your land and there I will let you eat some of me." When they prepare what they have, they go to travel. First Woman asks, "Where is it, this land?" He says to her, "The land is still far off."

Muwin-iyul takes them on a white path. This path takes them north until they get too cold. Then they follow him on a black path to the west. They walk until they come to black mountains. Then there is a red road that takes them south until it becomes too hot. Then First Woman asks Muwin-iyul, "Where is the land we are looking for?" He says to her, "The land is still far off." For some time, two weeks more or one month, they follow the bear on a yellow path. This path takes them east to where the sun rises. This is where they began, where they started out.

Here is where they stop. Here is where the bear takes them. This is the land where the sun rises. This is the morning land. This place is called Aben, that is, the Land of the Dawn. Mikchich and First Man and First Woman rest here for a while. They sleep for a while.

Muwin-iyul cuts off his tail, with his tail he will feed them. Then he makes a stew with his tail. He cooks this in a stone pot. The people awaken when they smell the stew. When they have eaten, after bear feeds them, they clean the stone pot, they scrub it with sand until it is clean. But when they put the pot down, then they smell the stew. Then the pot is full again. Now they know that Muwin-iyul is a wizard. Now they know that Black Bear has power in the land of Aben.

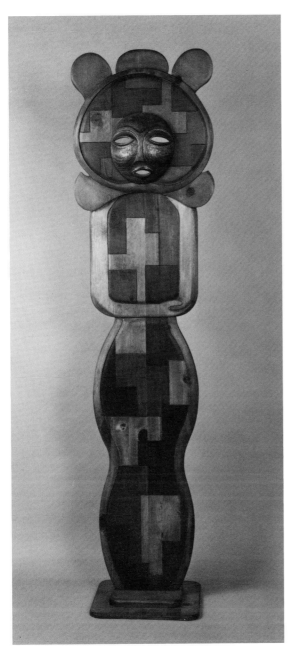

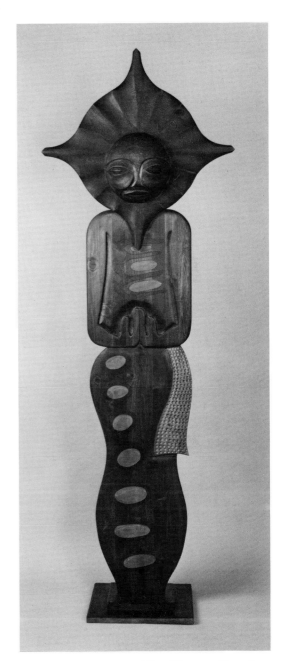

Mikchich the Turtle, Tsonakwa　　　　　　　　　　　　　*First Woman, Tsonakwa*

Deer Spirit

The whole assembly was disrupted. This boy, nine or ten years old, was horrified to hear that we killed deer and ate them. In tears, he kept asking me, "How could you do that?" Later, I found out from him that he didn't know hamburger, hot dogs, or cuts of meat in the grocery store came from living things. He thought they came from the same factories that make toys, candy, or sneakers.

—At an inner-city school,
Philadelphia, 1980

The first Pudjinks-skwes told our people to take the life of the Deer into our lives but not to take the spirit too. To preserve the population of Deer, the hunting must be reasonable and an account must be kept with the Spirit of the Deer. Through offerings (some, such as coffee, are very costly), prayer, and ritual, an arrangement is made with the Spirit of the Deer. This arrangement in time and place assures the willingness of the Deer to relinquish his physical life and charges the hunter with responsibility for the Spirit.

The hunter doesn't take the first Deer he sees, for this is a Spirit Deer testing him. The hunter must show that he isn't greedy and that his heart is right in this matter. Even though he has fasted to prove his great hunger and need, the hunter lets this first Deer go by.

When the right Deer is taken, the hunter should sit and cry for a while, tears must flow. Then a handful of soil should be eaten—this soil is the flesh of our Mother the Earth, who nourished the Deer. When we eat the meat of the Deer we should think of the soil of the Earth. When we see the blood of the Deer we should think of the water that flows on the Earth. When we see the Deer's bones, we should think of the rocks, the mountains that are the bones of the Earth. When we sit down to eat some of that Deer, we should offer something (tobacco or sugar are costly) the Deer would like.

We should use every part of the Deer to make something useful, something worthy. Clothing should be made from his skin. Tools made from hard antlers, bones, and teeth are good, too. The sinews of the leg make sturdy line and thread. The brain of the Deer is mashed and used to tan and soften skin so that it is comfortable to wear.

The heart of the Deer, we do not use. This we bury in the ground, his Mother the Earth. We bury his heart in a sunny place where it will be warmed under his Father, the Sky. We nourish it with something good like acorns or maple syrup. This heart will be the seed of a new Deer. A new Deer will sprout in the spring.

Whenever the hunter returns to that place where the Deer's heart is buried, he should give thanks. He should tell the Deer how good his meat and liver tasted. The hunter should pinch his side and show how fat he got from the meals. This is the beginning of another arrangement in time and place, the beginning of a new account.

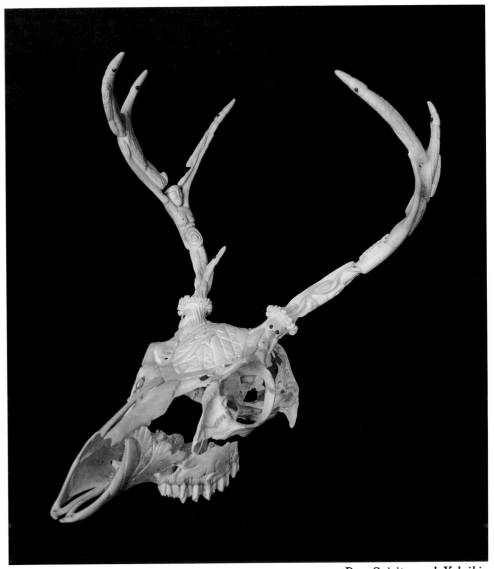

Deer Spirit vessel, Yolaikia

The Man and His Moose

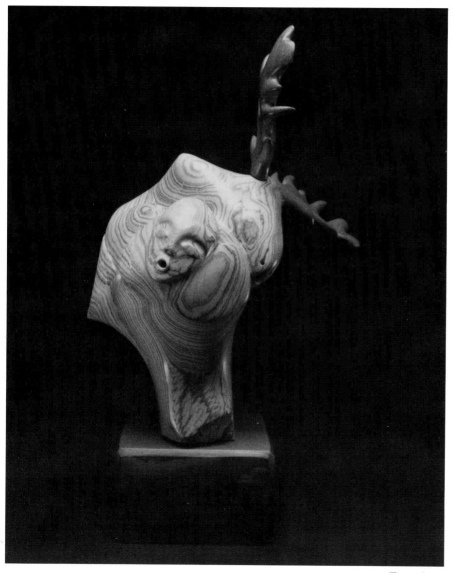

Tsonakwa

In older times, our people hunted the Moose with a special bow and a short, thick arrow. The Moose has such a thick hide that arrows could not penetrate deeply to give a mortal wound. The people knew that when a Moose is injured, it will find a safe place to hide and lay down so that the wound touches the Earth, our Mother. And so it is that wounds are healed by the earth. When the Moose was wounded with these special arrows, he would lay down with his wound upon the ground and thus drive the arrow deep into himself, making the wound fatal.

There was this man who lived in a village near Black Lake. He was not a very good hunter and didn't feed many people. He rarely came home with a Deer and his children never tasted Moose (even though some were almost old enough to get married). This man was not a very successful man, indeed.

Then came a good autumn day when this man went hunting in the forest. On this day, something went right with his medicine, there was something special about it so that the Watcher in the Forest decided to give him a Moose. The Watcher summoned the biggest Moose in the forest and

told him to give himself to the man; the Watcher would see to the spirit of the Moose.

Deep down, Moose didn't like this idea (he didn't become the biggest Moose because he was stupid) and he thought how bad it would look to his friends if he were taken by the worst hunter around. So Moose called out to the man, "Man, let me talk to you, I want to tell you something before you shoot me with that arrow." The man was amazed by the size of the Moose (he didn't know they could talk, either). So the man and his Moose sat and talked. Moose said these things: "You are very lucky to have me, for I am the biggest and the best looking Moose around. I am concerned about something, though. If you shoot me, skin me, and cut me up, no one will know how big and beautiful I am. You could be a lot prouder if you took me to your village in one piece so everyone could see. You should put me in your pack just as I am." "But how could I carry you that far?" the man asked. "Don't worry," said the Moose, "I know a shortcut so it won't be that far."

So the Moose got into the man's pack and started giving directions. They went west to Missisquoi and crossed the bay. They passed by Odziozo, then crossed some streams and climbed some hills and finally approached the man's home at Black Lake, some days later. When at last they came within sight of his home, the man fell to the ground exhausted and unable to move. Moose got out of the pack, picked the man up, and carried him within earshot of the town, and let out a great Moose-bellow and did a great Moose-stamp so the people came out to see. And they were amazed to see such a big Moose.

Then the Moose put the man down and called to the people, saying, "I am this man's Moose, he got me and brought me home to you. I am glad to see you and your village and now I'm going and I hope I never see you again. Good-bye."

So that is the story of the Man and His Moose. You ask why I, the Caribou Man, would tell such a ridiculous story? The meaning of this story is clear. Sometimes you will get what you ask for and be sorry for it. Too much ambition can bring too much success, and the hardest part of hunting the Moose is carrying it home.

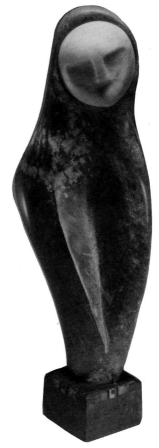

Tsonakwa

The Watcher is the gamekeeper-in-the-forest. This spirit tends to all matters of forest life, adding and subtracting, keeping a balanced account. In the hunt, he is all important to the outcome. He will assist the pure of heart, the good spiritual hunter, be it man or bear. He can intervene, tipping the scales against avarice or cruelty. He it is that arranges time and place, meetings of the spirit.

Pudjinks-skwes and the Night Child

Pudjinks-skwes had two daughters. Her first daughter was born in the daytime, she was a very beautiful child and very intelligent. As this child grew up she became very popular in the village and quickly learned all the social graces. She was invited to all the feasts and was followed by all the young men—indeed, they argued about who would sit next to the Day Child.

Pudjinks-skwes had a second daughter who was born in the darkest hours of the night. This child was very homely and seemed very stupid. Night Child didn't learn much of the social graces of the village, she was awkward and shy. She was so homely to look at that none of the young men wanted to be near her. She was never invited to feasts or dances. Indeed, so ugly was Night Child that the people wondered if she was human. Night Child grew accustomed to going out only in the dark hours and spending a lot of time alone.

Finally, in tears, Night Child asked Pudjinks-skwes, "Why am I so different from my sister? It doesn't even seem that we are related. I wish I were like her."

Pudjinks-skwes smiled and held Night Child close, saying these things: "These are things you need to know so that you will be happy. Your sister was born in the daytime and is very beautiful to look at, this is true. But you are a child of the darkness. Indeed, you are a relative of the Owl. Whereas you lack outward beauty, what you have inside is impossible for human people to see. Whereas your sister has learned so much of the social graces, you are filled with knowledge of the spirit, you know the dreams of the people and all the things of night. Feel sorry for your sister, she will never learn what you know, she will never be able to do those things of the spirit that are natural to you. Have compassion for the human people who cannot see in the night and are afraid."

And so Night Child felt better and set about learning from her mother Pudjinks-skwes and her father the Owl all the things of the spirit that she would need to know, and all the people came to her when they were sick or afraid.

Day Child learned to cook and tan hides and she became a very good dancer.

Pudjinks-skwes and the Day Child

I. Pudjinks-skwes na nekem wehnidcanehl ot'na tchipina-kwes-sidjik

Nit itasik Pudjinks-skwes na nagem wehnidcanehl ot'na Kiwak-wes, naka keskemmetaswino naka tchipina-kwes-sidjik. Wehnidcan mehsi mudjina-kwe-sholto; kitkihi wasis wemadj-kehna; wehkisi-ek-motnatmowan kehtehkihi epililjihi wehllikisatilidjihi wenidcanwa; wehmadjeknan taholo-te nekem wehnidcan.

I. Pudjinks-skwes conceives children by monsters

Now it is said that Pudjinks-skwes conceives children by Ice Giants, and giants and monsters. Her children are all ugly; she rears others' children; she can steal from (human) women their prettiest children; she rears them as if they are her own children. That is so she will not be ashamed, so repulsive are her own children.

II. Pusetiwi wasis

Nekweht wehkisi-kemotnalan weskinosis-ehl. S'laki wen wehttekwetjimolan; wehtiyan: "Kaht nit kil kikwus." Nemiyat wehpihanmom naka weh-siwes nit wedji kisinsitwuk taholo-te mudji

weyusis-ik. Ni-teh na ehl-matoti-tit; nakem-lo wehli-ko. Weht-ekwetjimolan wikwusehl: "Kehkwe nit wedji leyik?" Pudjinks-skwes wikwusowal teli-asitemal: "Nikteh-na nehmikwe-soltop-ehnik nipayi' kiluspetew kil puseti-wasis."

II. The Day Child

Once she had stolen a (human) boy. Then someone asks him, saying: "That one is not your mother." Then he sees his sisters and his brothers, how they are ugly like evil beasts. This then is how they are, but (the boy) he is handsome. He asks his mother: "What does this mean?" Pudjinks-skwes answers him: "These others were born in the night, but you are a day child."

— told to Pere Sebastian Rale ca. 1695, recited from mnemonic Wapapi Belt.

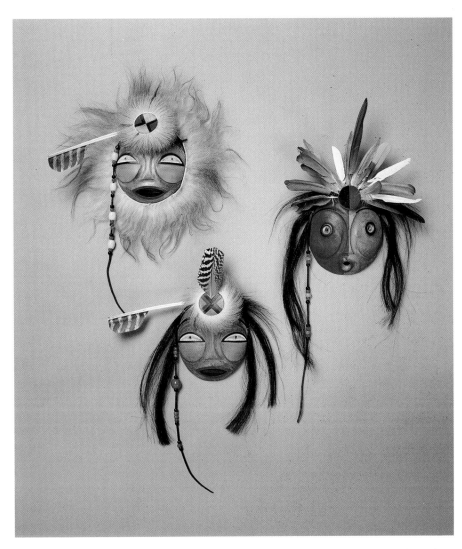

The Day Child, left, Pudjinks-skwes, and the Night Child , Tsonakwa

Pudjinks-skwes and the Dream Drum

Pudjinks-skwes meh'teaulin
Pokumkeskwe.
Epit kisi weh'skitape-weleso
tan-teh weh'lithat-ehk,
kenok-lo yut'l kisikol
weh'skitape-weleso.
Nit-tekiu, Pudjinks-skwes
sachem-awiu.
Weh'ketmakel kahanmiset-teh;
weh'kisima ketmakeyili-edcihi.

Pudjinks-skwes the witch was a
she-Blackcat.
Woman or man she becomes,
according as she wishes,
but in these days she is a man. So
then, Pudjinks-skwes is a chief.
To the poor man she gives; she fed
the poor.

—Ancient Wapapi Record

Then it was one of the first
nights of creation, soon after the
world was made, and Pudjinks-
skwes was there. She was one of
the first. In the first nights of
creation, there was nothing to do.
It was dark and no one could see.
People in those times just sat in
the dark because they had not
learned how to sleep. If they went
out in the dark, Fox had to lead
them—only he could see. They
held onto his tail. Pudjinks-skwes
thinks that this is no good, there
should be something to do.

One day these people go out to
gather eggs. When they go out,
they take a new path to the lake.
When they go down this path, they
see a great drum lying under a
tree. Now, the people think the
Manito left his drum here. When
they return, they approach
Pudjinks-skwes and tell her what
they saw. She gets a toboggan and
takes these people down the new
path until they see this great
drum. They drag this drum back
to the village on the toboggan.
There Pudjinks-skwes thinks
about this drum. She thinks she
will sing with this drum.

Now, at night when there is
nothing to do but sit in the dark,
Pudjinks-skwes beats the drum. It
sounds like a heart beating. It
sounds like a mother's heart
beating before we are born. It
soothes the people, this drum; it
gives them something to do in the
night. They are peaceful and fall
asleep, even Pudjinks-skwes.
While they sleep they walk down a
new path. When they go down this
new path it is a great dream, and
they see what the Manito sees
when he sleeps. They see the spirit
side of things. So this is a dream-
drum that makes us sleep and
makes spirits approach us.

When the people awaken in
the morning, Pudjinks-skwes says
to them, "Upon my favorite pipe, I
didn't think the drum would do
that!"

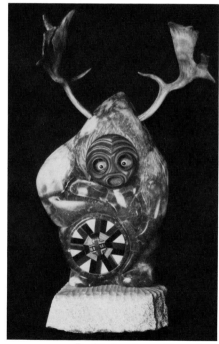

Pudjinks-skwes, Tsonakwa

The Weeping Butterfly

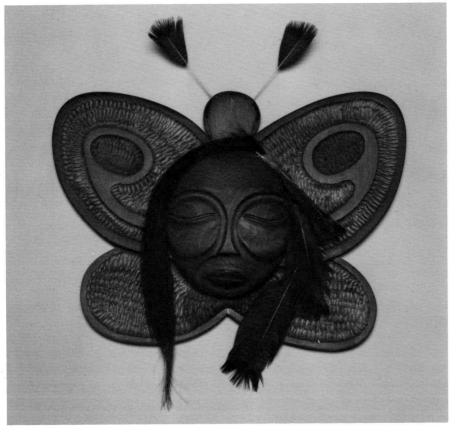

Tsonakwa

We start life as the children of parents and suddenly we find ourselves the parents of children. Changes in this world come as fast as the beats of a rabbit's heart. Changes in this life come on the drumming wings of a partridge. If not for change and difference, we would each be but a pine needle on the forest floor.

Do you see the tear in that butterfly's eye? She is heartbroken because of what happened to her. Just a few days ago she was a happy worm crawling around on the branches of a birch, she was a happy worm eating the leaves of a maple. Her sightless eyes revealed nothing to confuse her. She could not see anything frightful with her blind eyes. That is how she was when the Trickster found her.

The Trickster decided to do her some good, he thought he would do her a favor. He had a spider spin a magic cocoon and put her inside, a real magic box that was. When she came out this morning she had changed. She changed a lot!

Now she has long spindly legs and can't crawl on her stomach along the branches. So she just sits and cries. Now, she has these great big wings that she doesn't know what to do with and they are so heavy a burden to carry. Her mouth is changed so she cannot eat the bitter leaves she loves so much. She cries. The world is so full of things, she is confused. She cannot stand to look at herself, the colors and designs are not at all what she thought she was in her sightless mind.

She doesn't know what to do (a great tear wells from her eye). When she dries off and her wings unfold, when a gentle breeze blows her off that branch—she will think of something.

The Ice Giants' Shaman

*Nil nolpin naka ntet'li-tumen
pekholaken. Nitut-li-wikwitahan
weyusisik naka na petciu
wutcausen witciksitmakon
enpekholaken.*

*Nil nolpin naka ntet'li-tumen
pekholaken. Nil tlintowanen
niweskwuk.*

I sit and beat the drum. I summon
the animals and even the storm-
winds obey my drum.

I sit and beat the drum. I sing
on the path of the spirits.

—Lintowaken (Song)

This was the time that the Ice
Giants became too strong. They
were arrogant and used their
power. So much they used their
power that winter became longer
and longer each year. Spring, fall,
and even summer were made
short so as to disappear. There
was no other season, only winter.
Everyone shivered and stamped
their feet, what else could they do?
They burned sticks to make
themselves warm and nothing else
did they do. It was too cold to do
anything else.

Kuloscap saw how miserable
everyone had become. He was
angry to see the arrogance of the
Ice Giants. The people could not

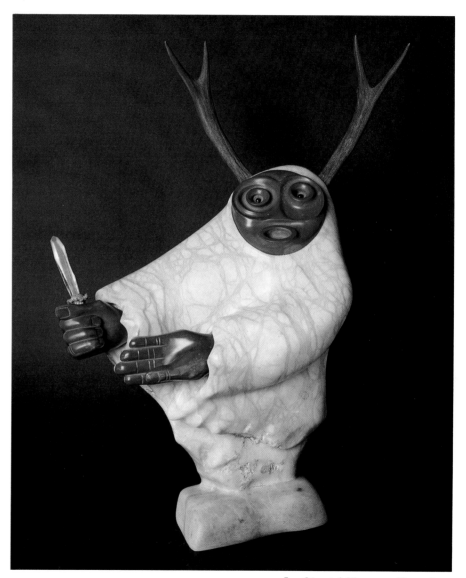

Ice Giants' Shaman, Tsonakwa

30

hunt or grow food. When he packed what he needed, Kuloscap went north to the back door of the world. He went to the rock at the end of the sky. Here is where the Ice Giants kept Wutchow-sen, the great bird who flapped his wings and made the North Wind.

When Kuloscap sees Wutchow-sen he says, "I sing on the path of the spirits, obey my drum." Wutchow-sen answers, "If I do not flap my wings the Ice Giants do not feed me." Kuloscap unstrings his snowshoes and feeds him this and Wutchow-sen is happy. When the Ice Giants see this they take Kuloscap and place him with his back to the rock at the end of the sky. Then he sticks fast to it and cannot get free.

The Ice Giants have a shaman. This shaman is an Ice Giant too, but he is a dwarf and no bigger than a man. He thinks Kuloscap is a kind man, that he is generous. This dwarf is tired of his family, they laugh at him. He is tired of their arrogance. He says to Kuloscap, "If I get you free, what will you do?" Kuloscap replies, "I will take you with me. You are no smaller than me and no one will laugh at you."

So, the dwarf makes a pick out of ice. It is so cold up there that ice is as hard as stone. The dwarf works all night. The Ice Giants hear pounding all night and laugh at Kuloscap, at his struggling. In the morning these two leave that place and Kuloscap is carrying a big piece of that rock on his back. The Ice Giants cannot torment them on their way because the dwarf knows all their tricks.

So it is now, winter must share the year with all the other seasons. The great bird Wutchow-sen knows that people are generous and only flaps his wings occasionally when he is very hungry. All we need to do when the north gale blows is sing the song to Wutchow-sen and hang our old snowshoes out the door. And now the Ice Giants cannot torment human people because their dwarf taught us all their tricks.

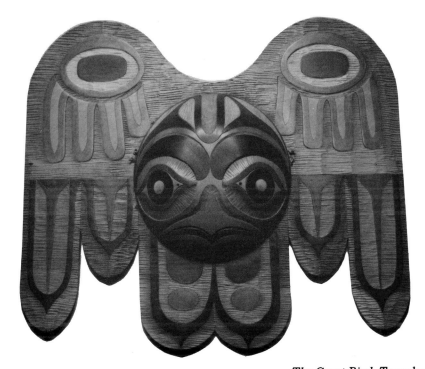

The Great Bird, Tsonakwa

31

The Shaman at Lac Nichicun

My friend, out here we do not live by the counting of hours. Time is not the same in the mighty face of nature as it is in the cities of men. Anyway, the sense of time depends upon how life is lived. To a captive, the days are long, indeed. To a grandparent, the years have flown as quickly as birds. Out here, we live by the lengthening of shadows, by the short span of dawn to dusk. We know that with coming winter the days shorten to endless dark. The Ice Giants exhale and we, like fallen leaves, are blown into the dead of winter, with the howl of demons into the dread of longest night.

Benjamine was of mixed blood. His father was Inuit and his mother a Naskapi. Nothing is known of the father; he was never mentioned, but this shaman and his mother lived alone at Lac Nichicun for quite some time. They were outcast for the fact of the mixed relations—there were strong social rules among their people in those days. So it was that they lived alone with some social stigma at Lac Nichicun, north of Chicoutimi in Quebec.

A combination of circumstances led Benjamine toward a shamanic personality.

Isolation with the immense natural forces of the forest was an able teacher. Social and psychological stress from his situation was a strong catalyst. Also, some shamanic progressions can be regarded as a form of psychosis. This most likely was the case with Benjamine, who suffered through recurrent bouts of depression and many episodes of "hysteria." These illnesses were overcome only by Bejamine's inherent spiritual strength. With the assistance of his caring mother, Benjamine made a good recovery. Indeed, it was his own ordeal that taught him the process of healing and he learned it well enough to help others to recovery. Through the 1940s to the mid-1950s, he evolved a good reputation for his healing abilities. He built up a "practice" that extended for several hundred miles, and his specialty was winter hysteria.

Winter hysteria, or "cabin fever" as it is commonly called, is a widespread and difficult problem in Canadian winters. It has many apparent causes including extreme isolation, prolonged darkness, foul weather, long confinement, and, not the least, alcoholic drinking and the ensuing delirium. One of the more common and interesting complaints is of the shrieking and incessant wind of the winter storms—the Howling Demon. The symptoms develop insidiously from depression to full blown psychotic episodes leading to suicide attempts, delusions, or even homicidal rages. There are stories of entire villages disappearing in pre-settlement times in the arctic and the most common explanation is winter hysteria. A victim with severe symptoms was brought to Benjamine at the end of winter in 1956.

This man was brought to him from a hunting camp on the Misstassini Plateau. He had to be restrained for several weeks after attempts at suicide and several violent attacks on members of his family. Finally, remorse overcame him and he fell into a deep depression. It was in this condition that he was brought to Benjamine.

Some time was spent in the interview and diagnosis, after which Benjamine prepared himself to "go into the patient." Bejamine's familiar battleground was inside himself, for it was there that he learned healing in the first place. He would take his patient's symptoms into himself and deal

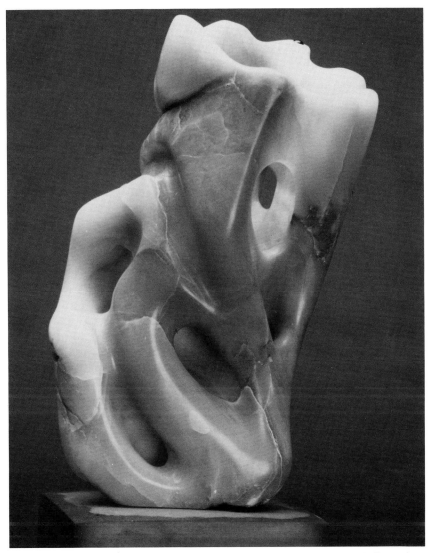

Shamanic vessel, Tsonakwa

with them there, and so effect healing. After several sessions over a period of several days, the patient was cured of his illness well enough to start home with his happy family. After these people left, Benjamine attacked his mother, beating her severely, and then drowned himself in Lac Nichicun.

Fire is a wondrous thing. It lights the darkness of night so that the people are not afraid. It is warmth against the cold winds of winter so the people do not sicken and die. Deep in the soul of man there is a fire that is the Fire of Life, a gift from the Son of Thunderbird. This Fire gives the light of knowledge that drives off the cold winds of loneliness and hate so that the spirit of man will not sicken and die.

Each person must tend his own Fire and keep it bright. Each must gather fuel and feed it lest it wane and die. And surely as the Fire dies, so does the body too. So long as there is the smallest ember, there is hope. This Fire can be shared with many people, for as many are warmed and lighted, nothing is taken away and it burns all the same. But stay near the Fire—the farther from it you go, the less of its benefit you will receive. This may have been the undoing of Benjamine.

When Grandma Became an Owl

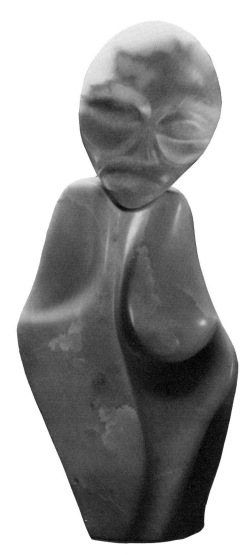

Grandma, Tsonakwa

You will know the time, all things are a meeting with time and place. When at last you have become what you are, the Owl will call your name and you will be the only one to hear. Pack a few things—you won't need much—and then walk straight ahead and don't look back. Go on to the land of the Owl.

No one knew how old Grandma was. She was born before there were any records kept, before we were civilized. She lived in the small house near the maple house and there she could have her privacy and dignity while being close by for people to keep an eye on her. She was very old and unable to do everything for herself, so two of the grandchildren were made helpers. Young Gerard cut wood for the fire and carried water. Laura helped clean and accompanied Grandma on her walks.

Grandma had begun to act strangely in the past few years. Sometimes she would talk funny and would say words that no one understood. Sometimes she would talk to people who were not there. On her walks she gathered strange twigs and leaves and would laugh as she put them in her bag, which she kept near her at all times. This went on without great concern until that autumn morning that she cooked "the breakfast."

That morning, Gerard and Laura went to check on Grandma and see what she needed. Grandma was up early and busy as usual, cooking her breakfast, which this morning smelled awful. When Laura looked in the pan to see, she was surprised to find several mice and a frog cooking in the pan, and they weren't even cleaned. Now, the family became concerned. A meeting was arranged with the elders the next day to see how to deal with this strange behavior.

The elders were told all the things Grandma was doing, the strange language she was speaking. They were told about the bag she kept near her at all times and how in the middle of doing something she would suddenly begin dancing a strange dance. Last of all, they heard about "the breakfast." The elder members of the family sat in silence to hear all these things and said they would think about them for a day and then decide what might be done. They left that night, looking worried.

The next evening, the elders came back and they all looked somewhat relieved. They looked

like they had solved the problem. This is what they told the family to do. They said, "Do nothing, because everything that is happening is natural. We don't know how old Grandma is, she has been here a long time. Sometimes when people get as old as her, they act strangely, but there is no harm in it. Maybe she is becoming an Owl and is only doing what an Owl should do. We all know that between us and the land of Spirits there is the land of the Owl. We must all go through the Owl's land one day. But in the case of ones like Grandma, she has become so old that even though she is still in this world, she spends her nights in the land of the Owl. And so it is, she gathers leaves and twigs for her nest. So it is the strange language she speaks is actually the language of the Owl. So it is when she flies about at night, she catches mice (how else could she be quick enough) and likes them to eat. So you see, at night, in the Owl's time, Grandma becomes an Owl. When day comes she turns back into human form, but her mind is old and slow and remains the mind of an Owl. Now we can understand the things she does and the things she likes to eat and that this is only natural."

During a hunt for raccoons in October, 1916, great-uncle Albert shot an owl by mistake. That morning, my father and aunt Laura went to check on Grandma. She was not up early cooking her breakfast as usual. Grandma had gone at last to the land of the Owl in her sleep.

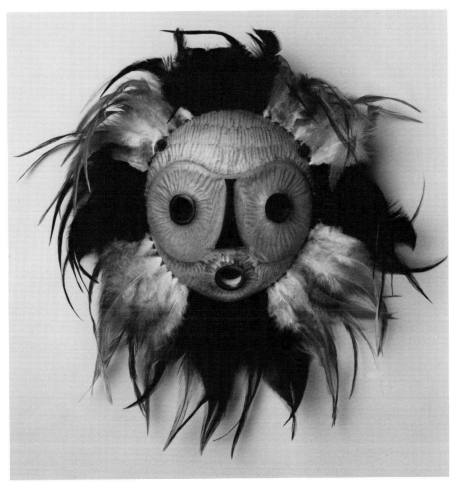

Owl mask, Tsonakwa

The Wapapi of the Children

The Wapapi of the children, and how they are made to stay in our world

When a child is born, and he is made human, then the parents should do this thing. It is for them to do. They must put the moccasins of our people on the child's feet. But, cut holes in the bottoms of the moccasins because the child is not fully in this world yet. He has a doorway in the top of his head. Through this place, this soft place in the top of the head, the Creator whispers to the child. And so we see him smile when he sleeps. Because, when a child sleeps, he goes back to the spirit place whence he came, and he sees the great beauty of the spirit place from which we all came. And so it is when a child comes into this world he cries because he is afraid of this new place—it's not as beautiful to him as being in the Creator's face. We cut holes in the bottom of his moccasins so, as he sleeps, the child is free. He is not confined. We do not force anything upon the child. And through the holes in the bottom of his moccasins, he is free to come and go between this and the spirit place.

Sometimes a child doesn't come back, and he is gone from this world. That is because we must do this—the spirit place that we came from is so beautiful. When the door in the top of our head finally closes we forget that place, but the child sees it in his sleep and he flies back and forth. That place is so beautiful that sometimes a child wants to stay there. And so, to make that child human, we must show him the great beauty of this place, so here he will decide to stay.

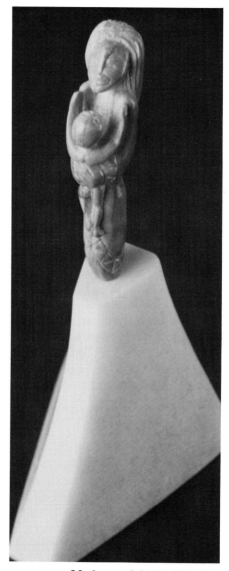

Mother and Child, Yolaikia

36

When a Child is Born

When a little child is born, this is what you should do: When a child is born the aunts deliver the child and wash the child and dress it in fine clothes. And then the grandmothers are brought in and they sit down in front of the child and its mother. Then the child should be handed to the grandmothers, and the grandmothers should look at this child sternly, and they should shake their head in a knowing way. And they should say sternly to this child, the grandmothers should say this: "Welcome to our world, little child. For this is our world. We have been here a long time. But listen, little child. We hear secrets whispered in the breezes that blow out of our mountains. We hear the songs of the wind from the Lorentag Mountains as it disturbs the water of the lake. We have heard it whispered in the bowel of the maple and the birches. We hear the voice of the wind in the bushes and the grasses. And it speaks, saying, 'Look now, little child. For already you, too, are an ancestor to generations still to be born.'" And that is the Wapapi, the record, of how a child is made to be human. It is finished.

Anthropomorph of Reason

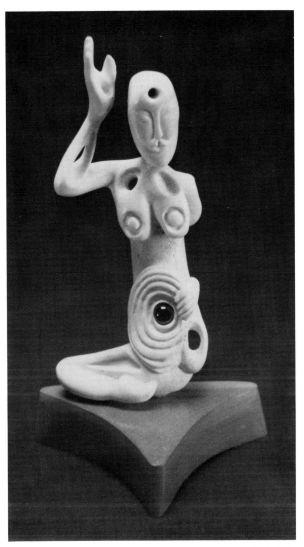

Yolaikia

Painted Deerskin

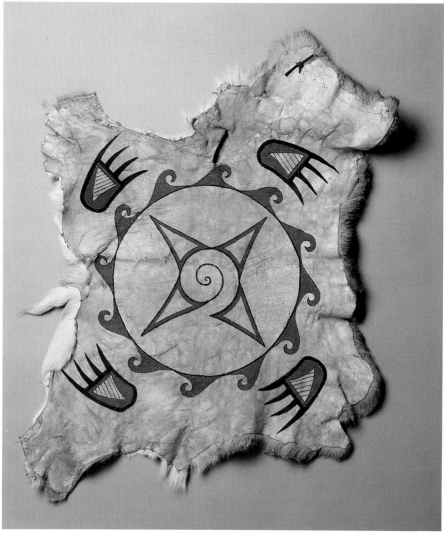

Tsonakwa

White-tailed deerskin that has been brain-tanned and smoked over cedar and oak. The skin has been shrunk in this process and the hair has remained intact.

Deer is a nurturer, the most important food source of the Abenaki since ancient times. Deer is female generally—even the antlers of the male deer are a gift from the female forest entity.

The design is in red and black ink, which came into use with the earliest advent of the Europeans. It was readily available as "ledger ink" used in bookkeeping by traders. The use of red and black colors predates Europeans, going back in time to the Red Ochre Culture 3,000 years ago. Red symbolizes blood and life, with secondary meanings of warmth and love. Black symbolizes Darkness and Death, and also mystery.

The center design is the Abenaki Creation Star, with its central spiral, the birth canal of creation. The spiral opens to the East, the direction of Aben, the homeland. The star is within the Circle, the outline of the shell of Mikchich, the Great Turtle. The circle symbolizes the North American Continent, cycles of life and seasons, and celestial movements. Around the circle are Waves in red, symbolic of emergence. Mikchich emerged from the primordial ocean, more likely red-hot lava than water. We

emerge at birth from darkness through water and blood.

The Bear Paws stand for the Bear-Trail: "We follow the Bear," tracking the Bear and learning his ways. The Paws are at the four directions, illustrating the original migration of the People to Aben. "Aben" means "Land of the Dawn"; "Aki" is "people from"—thus, Abenaki, people from the Land of the Dawn. Our knowledge of the four Spiritual Directions and their characteristics is spiritual geography, and comes from a very ancient time.

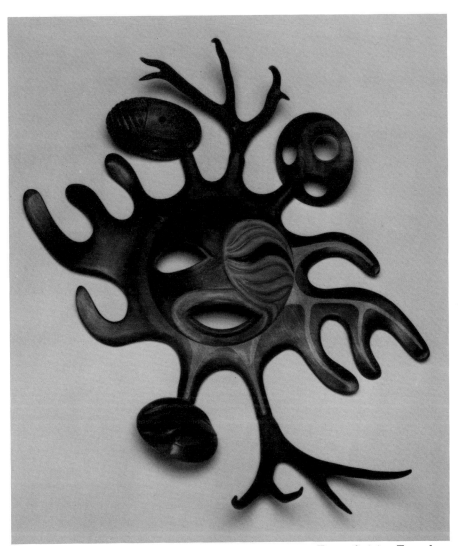

Forest Spirits, Tsonakwa

Ancient Clans

What has come to the ancient clans of the earth that they have withered within a short recent time? So many great nations of nature are gone and their few remaining survivors are tolerated or treasured as rare curiosities. The earth-shaking herds are stilled and sun-blotting flocks are silent. Their nations died without prayers, there was no one to bury their hearts in the ground. There were no rituals, nor offerings of tobacco, acorns, or maple to placate the spirits, to entice them back. The spiritual account was ignored and the net loss was extinction.

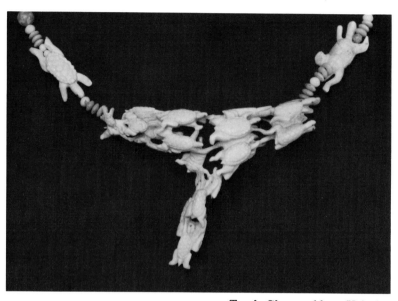

Turtle Clan necklace, Yolaikia

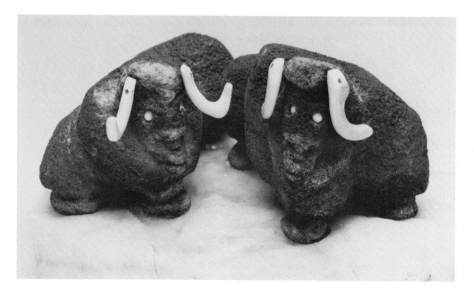

From inside the fence of their compound the primordial Musk Oxen and Tortoise, with eyes so wizened, stare out bewildered at a world of terrible change. Obsolescence and progress are the defining terms of this age that confines them, that relegates old people to nursing homes and barricades ancient cultures in reservations.

Musk Oxen, Yolaikia

The Dancer

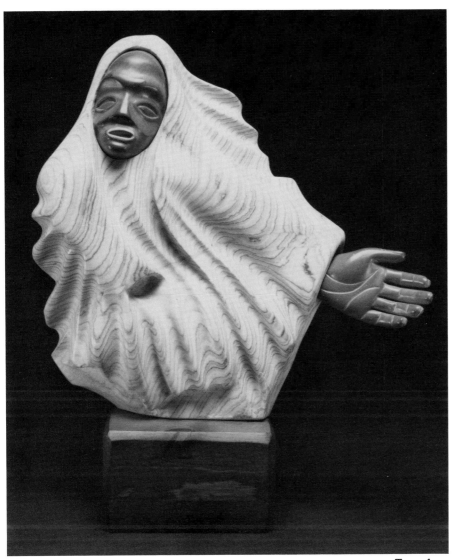

Tsonakwa

This dancer is completely taken up by the dance. He is transformed by it because it is a prayer for all of life. Nature taught the steps and set the tempo. All of nature is testimony to the Creator.

All of nature is a joyful movement of life. The four-legged dance quickly upon the earth. There is a happy splashing of fins in the waters. Great birds trace slow circles in the empty, endless sky.

In nature, man lives among the flickering shadows of the forest, the ponderous movement of great animals. Life is timed to the thunderous migrations of herds as well as the scurrying of a mouse in the golden autumn grass and the gracefully stalking snake.

Mother Porcupine Goes into Town

Inside the alabaster vessel are the spiky outlines of little porcupines against the backdrop of a city-scape.

Mother Porcupine is taking her children into town to do some shopping. She needs fabric to make curtains. The kids need new shoes and some pencils with erasers for the first day of school.

When I see my family and all native peoples living in the great cities of men, I think of how alien they seem in this setting, how frightened. Can they hear the spirits over the noise of traffic? Can they feel the Earth under the asphalt and concrete? They can't see the stars at night because of the glare of billboards and the blinding neon lights of taverns.

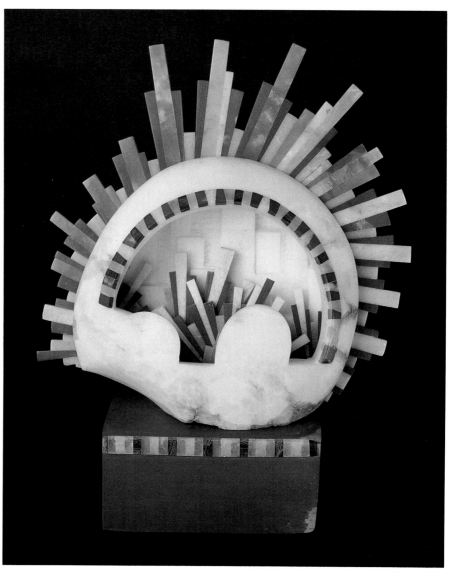

Tsonakwa

42

Bear with Sweets

Yolaikia

Bird Elements

Amulet, Yolaikia

These are no particular birds at all, for they are the essence of all birds. Because their domain traverses the earth and the sky, birds are well suited to a position close to the Creator. They perform many celestial tasks such as shepherding souls or carrying prayers. Even their feathers can affect healing and their songs are the sweetest in this world.

Migration Spirit

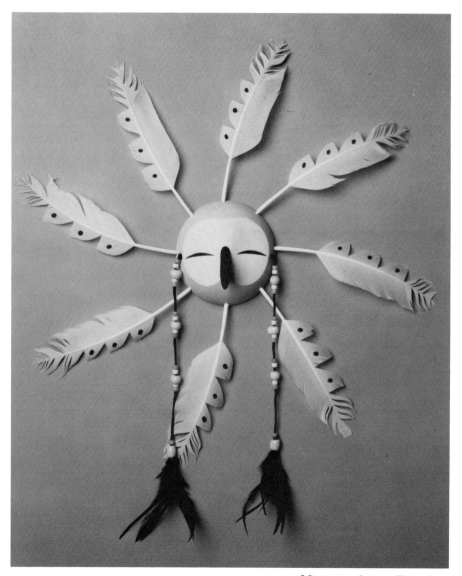

Migration Spirit, Tsonakwa

In older times, animal migrations were events of a magnitude hard to imagine today. A single herd of buffalo could take five days to pass. Passenger pigeons flew in flocks so great that they blotted out the sun. Caribou shook the earth in their journeys. Salmon and Shad choked the rivers and streams, making them overflow their banks. Even the human people moved in great circles upon this land. All things were guided by the same Great Spirit.

In Autumn time, the great birds begin to form flocks on the lakes. These are not the raucous gatherings of Spring; this is a quiet and solemn gathering and the lakes are filled. It is a mystery. Then, at but a single whisper from the Creator, they wheel their great formations into the greying skies and they are gone. Far to the south they fly, to a place that our eyes cannot see nor our minds conceive. It is a great mystery.

Winter comes with the terrible cold, the dark. The rivers and lakes freeze. So harsh the weather is, the animals dig holes into our

The Juggler

mother the Earth to hide themselves inside. The old, the weak, and the sick die and the land is covered in snow. Nothing moves.

It seems that just when despair becomes the greatest, we hear the great birds. They come with returning Spring, crying against the broken sky. Then, the rivers begin to flow again and are filled with joyful splashing of fins, the animals come dancing out of the earth, and our mountains turn so green we think we have never seen them before.

Always the great birds are on time, always they know the direction. Never are they lost in their migration. The Creator guides them.

So it is with the human soul, the spirit. We must pass in the winter of life, all things that live must die. We go to a place the human eye cannot see, the mind cannot conceive, it is a mystery. The spirit is always on time, always knows the direction, the Creator is the guide to a promised springtime. It is a mystery.

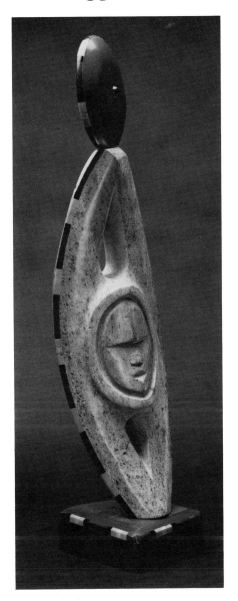

Magicians, contortionists, and jugglers had their place in ancient society. They gave respite in long ceremonies or brought levity to tense political situations. This juggler does things that seem impossible—by his example people are encouraged to undertake difficult tasks.

Tsonakwa

Autumn

Autumn arrives with a bunch of Bittersweets and Maple leaves in a water glass on the kitchen table. Its memories are stored in paraffin-sealed canning jars and stout cider jugs, to be savored again in a distant time. All the leaves and blades of grass were alive and children were not long ago in vermilion woods and golden meadows.

A long way from home in years and miles, I saw through a small window the sad leaves lying upon the ground in a dark November rain. Ahead was uncertain winter, but beyond that, the promise of spring.

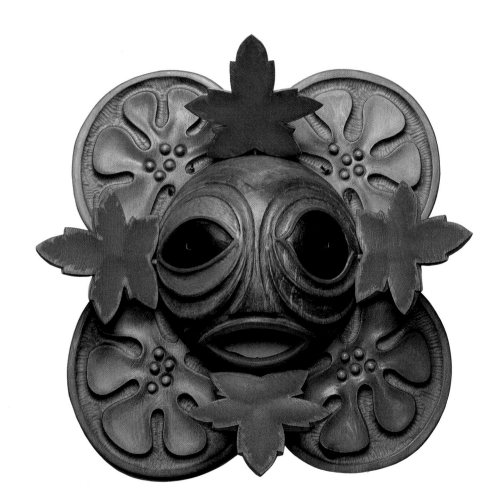

Tsonakwa

46

Farewell the Caribou Man

How beautiful were the mountains,
how green the leaves came out!
How fair the sky and clear waters,
how bright the moon!
When in the lonely winter wood
here on the mountain I wait,
sleeping in the ground like a wolf,
I will dream of you. Forever.

—Abenaki Chief Greylock's
farewell to the land of Aben

I have told you these things so that you will know them. Take what you can use of this and leave the rest behind. Pack what you need and go on your life's journey, follow the river that is your life. Help the animal spirits and they will be your allies along the way. If you are lost, look up to the night sky, the stars that sing will guide you. When you are uncertain, listen to the Dream Drum inside you that is your own heart— therein lies your true vision. If in the greatest darkness of your life you are afraid, then, like fireflies all about, kind spirits will light the tangled forest path. Do not fear the end of the journey, it is only the beginning of one that is new— a great adventure indeed! The Great Spirit is in everything and there is no death after all, only a change of worlds.

Now, you must stay and I must go. You have the world of men and animals, this Creator's box of magic where everything changes—nothing lasts but the ocean and the sky. I will return to my place of dark mountain valleys, shadowed lakes, and nighttime skies with stars like grains of sand, where caves are bright and nothing changes except the perception of space and time.

When I am gone, think of me as I will think of you. For now we are friends and shall be for a good long time. Look for me in the dreams you dream. And know, dear friend, you are always welcome in mine.

—Caribou Man, Aben, 1992

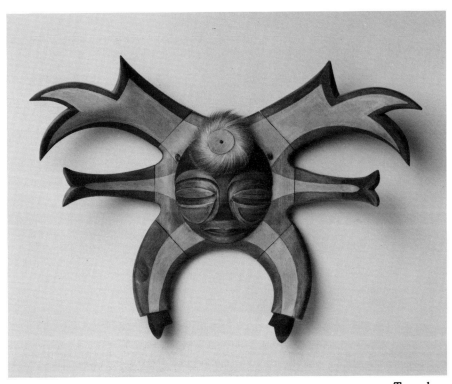

Tsonakwa